FAIRY GIRL

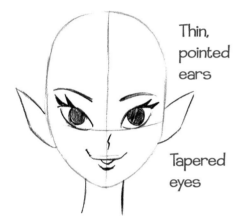

Begin by drawing an egg shape.

Thin, pointed ears

Tapered eyes

There is no more enduring theme for the cartoonist than enchanted storybook characters. Some of the most popular and beloved characters of all time are based on enchanted characters. The fantasy genre features princesses, fairies, genies, and more. If you want to create a little magic with your pencil, follow these simple steps and bring your characters to life. Fairies, for example, are drawn with elegant simplicity. Their trademark features are upturned, almond-shaped eyes, a little nose, and—of course!—the pointed ears.

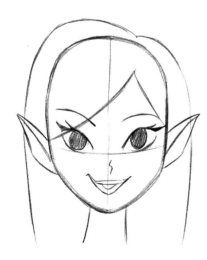

Dreamy hair

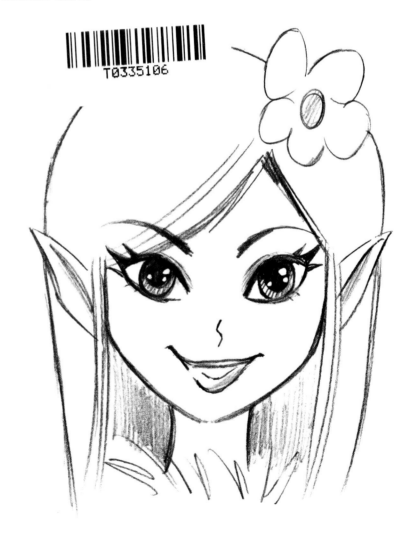

PLAYFUL FAIRY

Fairies can also be quite mischievous, as you can tell from this one's sly smile. Oh yes, they can cause quite a lot of trouble if you let one in your home. But who can resist?

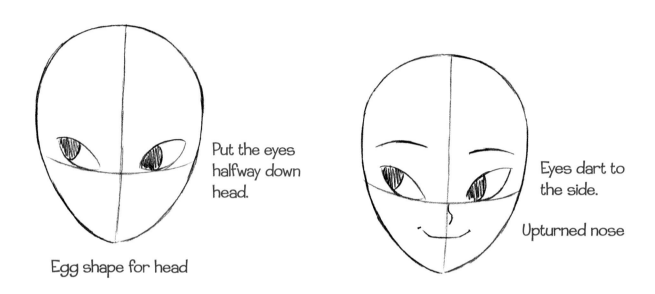

Put the eyes halfway down head.

Egg shape for head

Eyes dart to the side.

Upturned nose

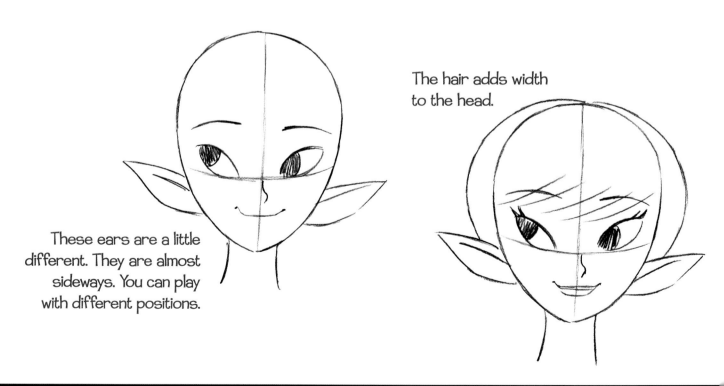

These ears are a little different. They are almost sideways. You can play with different positions.

The hair adds width to the head.

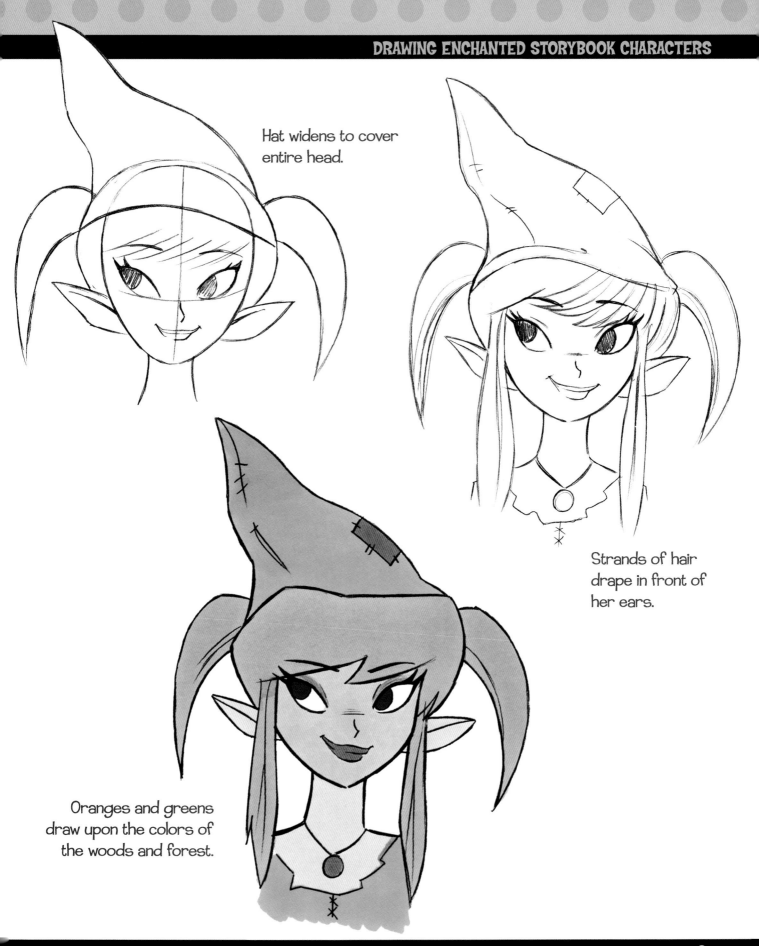

Hat widens to cover entire head.

Strands of hair drape in front of her ears.

Oranges and greens draw upon the colors of the woods and forest.

PRINCESS

The young princess is the center of many classic fairy tales. A lot of them have been made into popular children's books and animated movies.

Big hair

Round face

Indicate a thick collar.

Bangs

A little royal pet!

Small crown or tiara

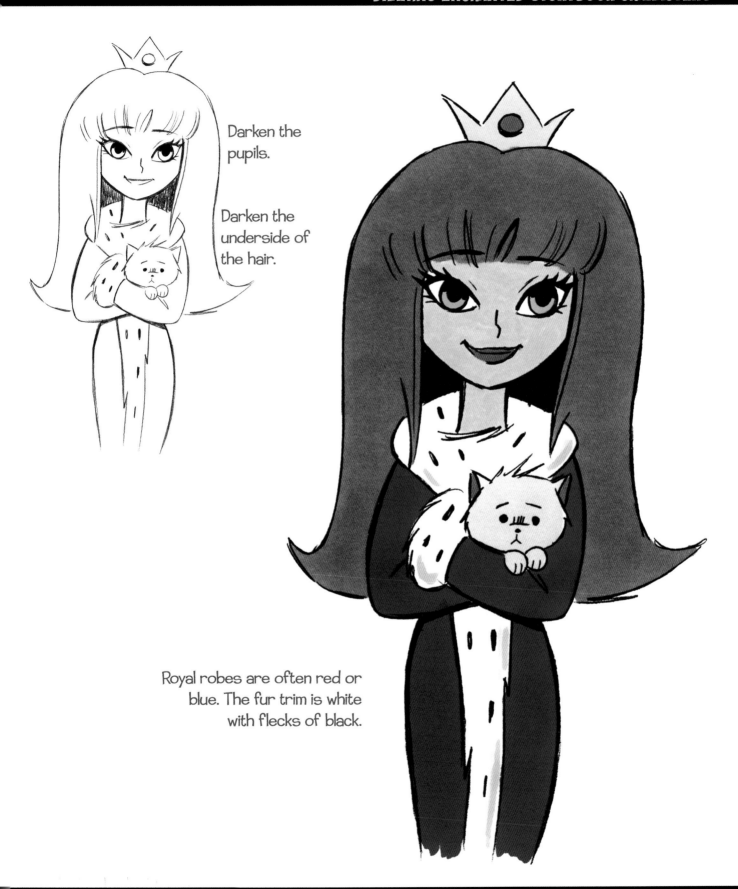

Darken the pupils.

Darken the underside of the hair.

Royal robes are often red or blue. The fur trim is white with flecks of black.

UNICORN HEAD

The unicorn isn't just any horse with a horn on its forehead. The horse character needs to start out with a charming fantasy look. Let's see how!

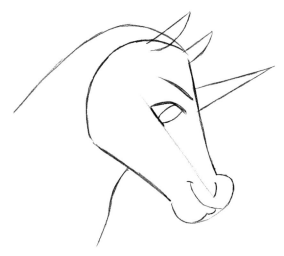

Draw an oversized, glistening eye to create a magical look. Pair it with a thin, graceful eyebrow.

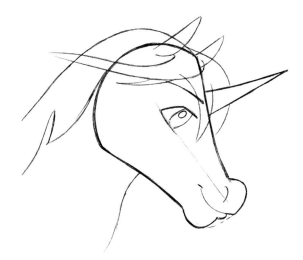

Hair falls in front and behind the horn, framing it.

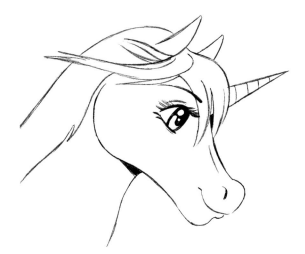

Small smile

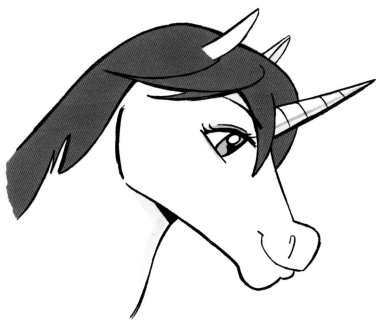

Use fantasy colors for the mane.

UNICORN FULL FIGURE

The unicorn may look elegant, but she should also appear strong. Her forelegs and hind legs taper to small hooves, and her mane and tail are fancy. Also, note the use of eyelids and eyelashes. The oversized, sweeping arc of the tail gives her an enchanted look.

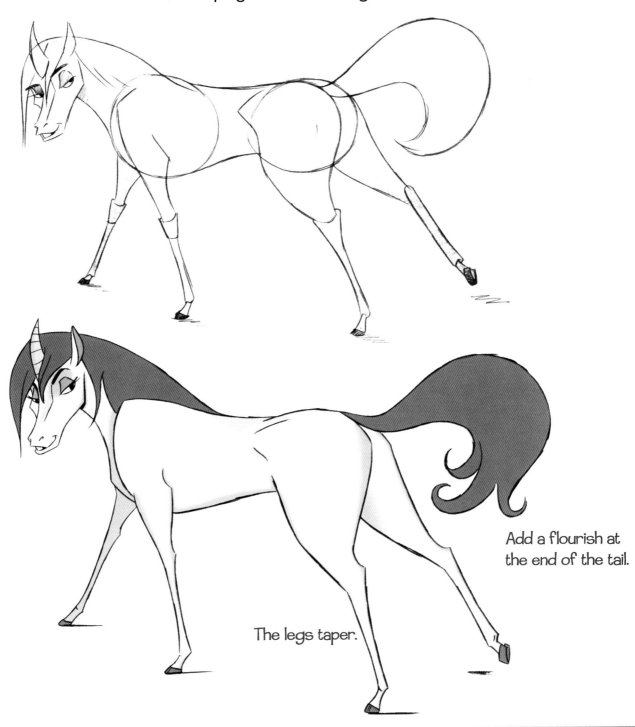

Add a flourish at the end of the tail.

The legs taper.

PEGASUS

Pegasus is a flying horse with feathered wings. Pegasus has a huge wingspan, which it needs to convince the viewer that it can fly. It also makes it more graceful. The secret to drawing Pegasus is to draw the horse's body in a gallop, as the extended wings keep it aloft. The combination creates a beautiful image.

Overlap circles to create the look of the body in perspective.

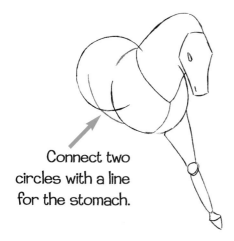

Connect two circles with a line for the stomach.

Tuck the leg underneath itself.

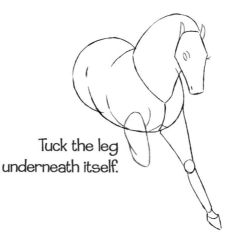

Equine Legs

The line of the leg follows the muscles to the joint, where it tapers to a small ball before widening out again and descending to the hoof.

The back leg is small due to perspective.

A curving tail adds to the feeling of depth.

Draw the wings at a 45-degree angle to show movement.

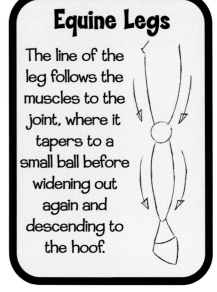

Reach out with the foreleg.

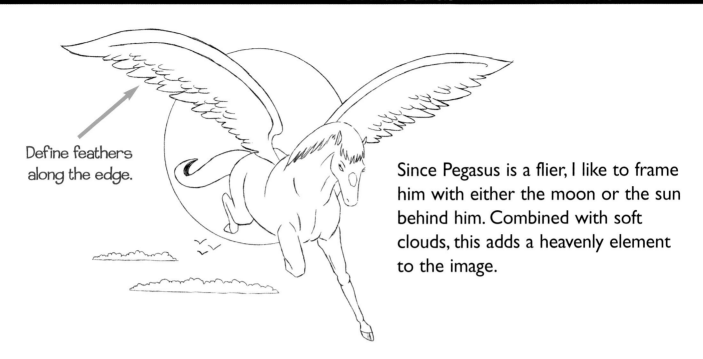

Define feathers along the edge.

Since Pegasus is a flier, I like to frame him with either the moon or the sun behind him. Combined with soft clouds, this adds a heavenly element to the image.

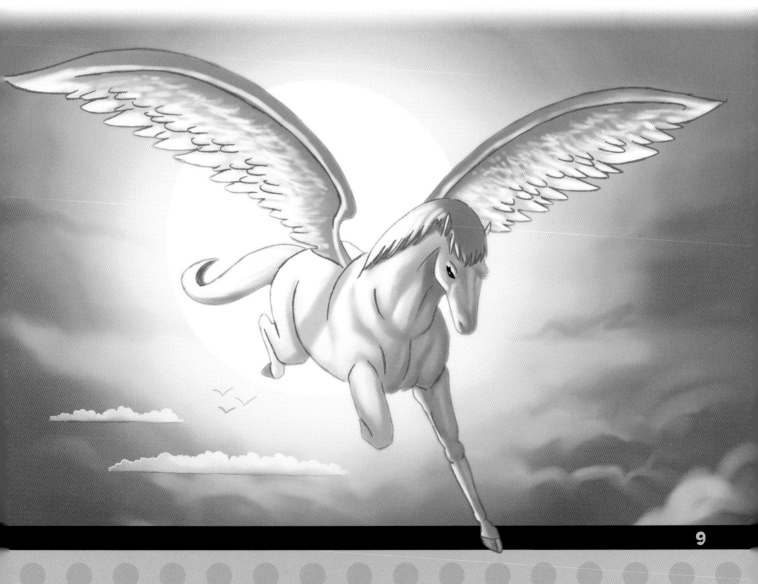

PRINCESS ON HORSEBACK

When you draw a figure sitting on a horse, the person should appear to sink into the saddle and not teeter on top of it.

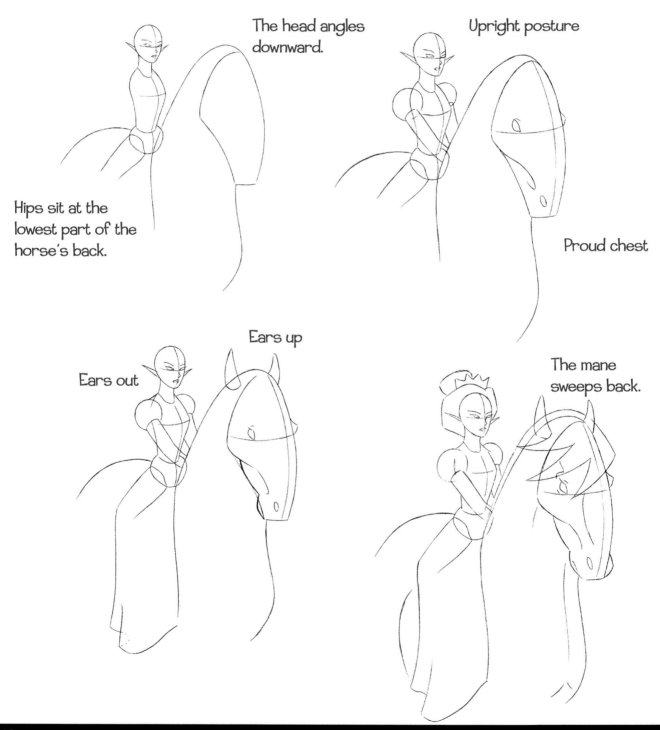

The head angles downward.

Upright posture

Hips sit at the lowest part of the horse's back.

Proud chest

Ears out

Ears up

The mane sweeps back.

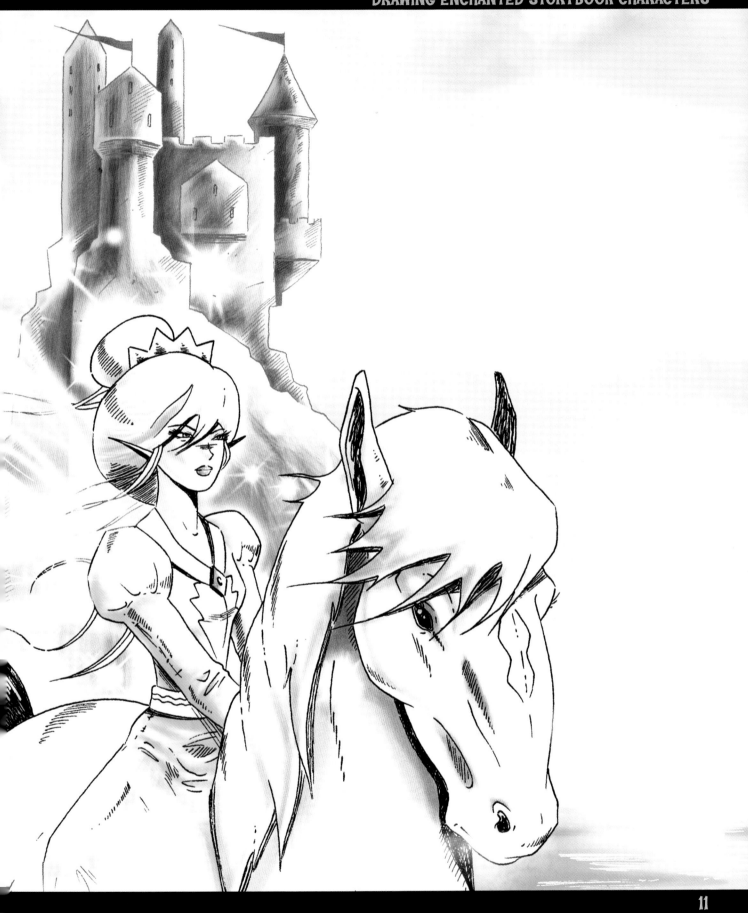

MERMAID

When drawing a mermaid's head, keep in mind that she is under water; therefore her hair flows gently, moved about by the ocean currents. Her body is long from the hips to the tail, but her torso remains normal size.

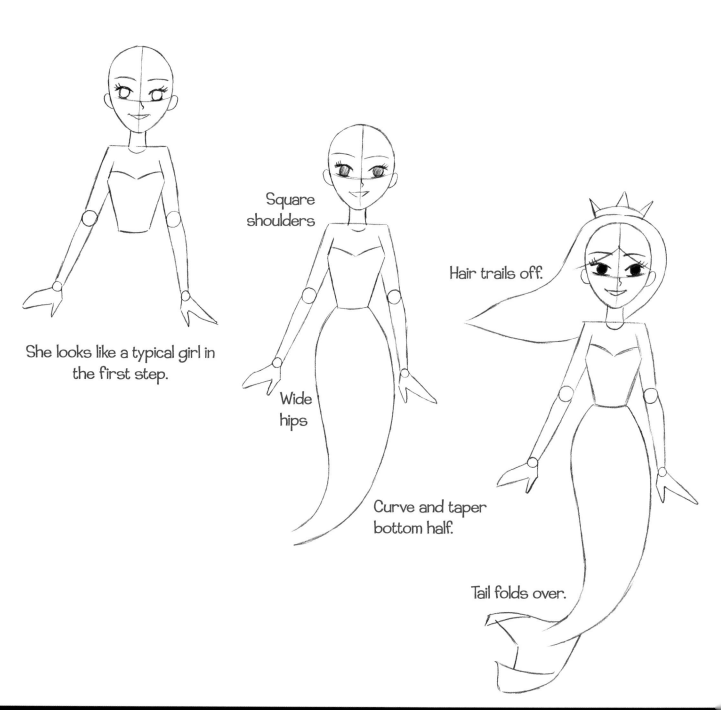

She looks like a typical girl in the first step.

Square shoulders

Wide hips

Curve and taper bottom half.

Tail folds over.

Hair trails off.

The three-pointed crown relates to King Neptune's three-pointed trident.

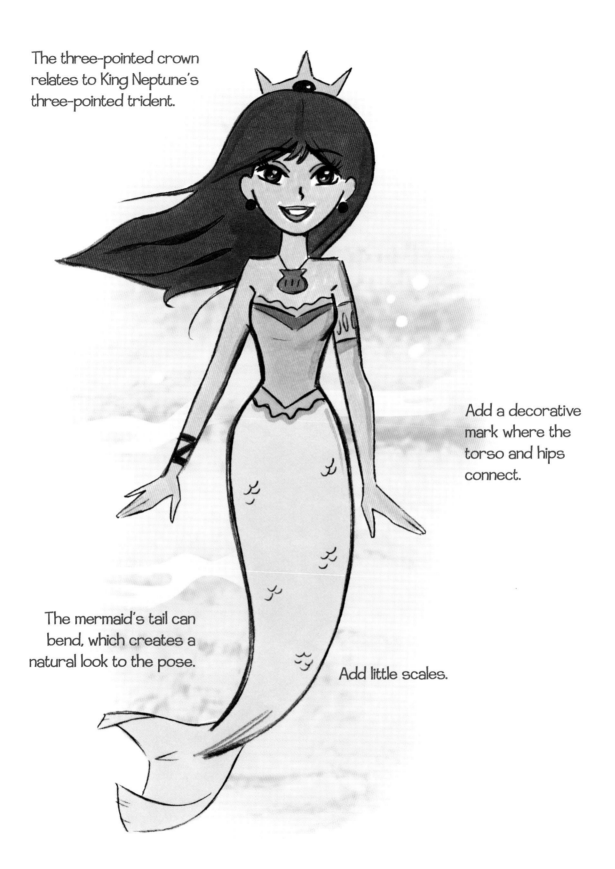

Add a decorative mark where the torso and hips connect.

The mermaid's tail can bend, which creates a natural look to the pose.

Add little scales.

GENIE

More than any other aspect of the character, the costume establishes the look of the genie. This being's playful spirit is apparent in its poses, too.

Slinky posture

Collarbone on angle

Leg out

Leg under torso

Pants bell downward.

Hips overlap arm.

Flowing hair

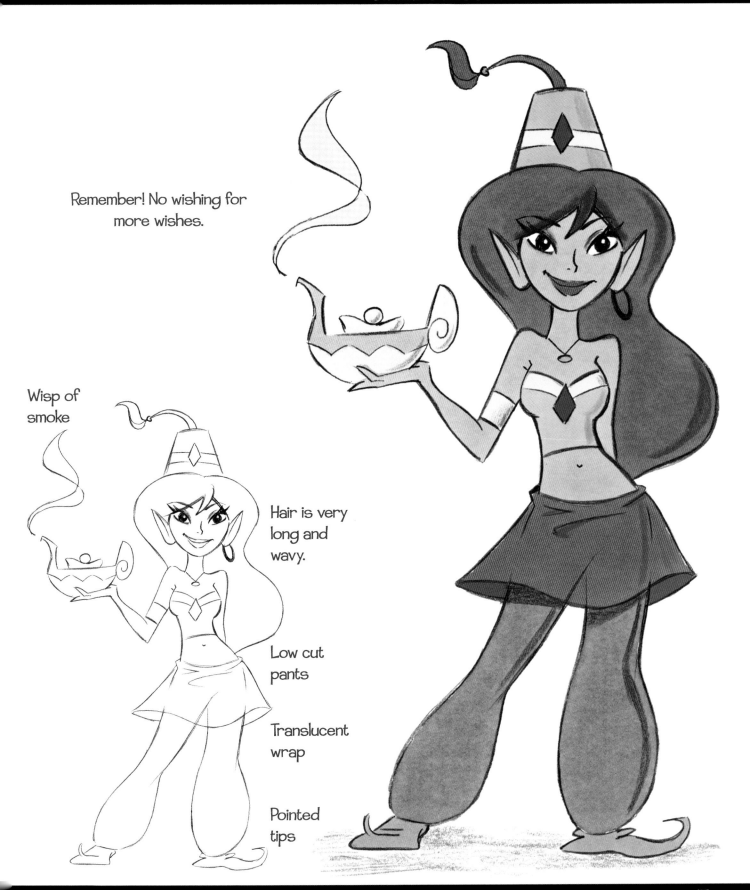

Remember! No wishing for more wishes.

Wisp of smoke

Hair is very long and wavy.

Low cut pants

Translucent wrap

Pointed tips

MALE GENIE

Perhaps the most famous "genie pose" is both arms folded over the chest. I can almost hear him utter the words, "Your wish is my command!" One moment later, everything usually starts to go haywire.

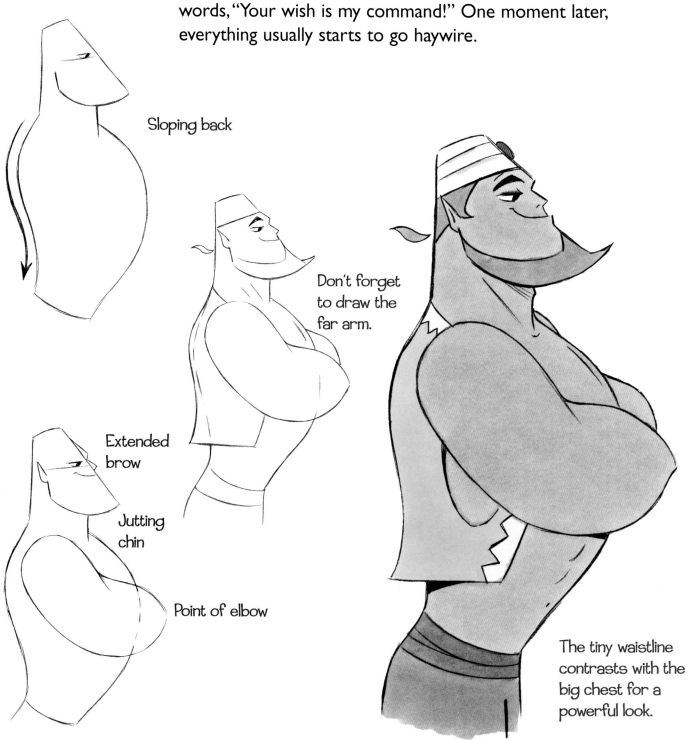

Sloping back

Don't forget to draw the far arm.

Extended brow

Jutting chin

Point of elbow

The tiny waistline contrasts with the big chest for a powerful look.

GNOME

While elves are often associated with winter holidays, gnomes are busy all year long. Gnomes dress like elves but with a slightly more contemporary look, such as this vest and turtleneck shirt.

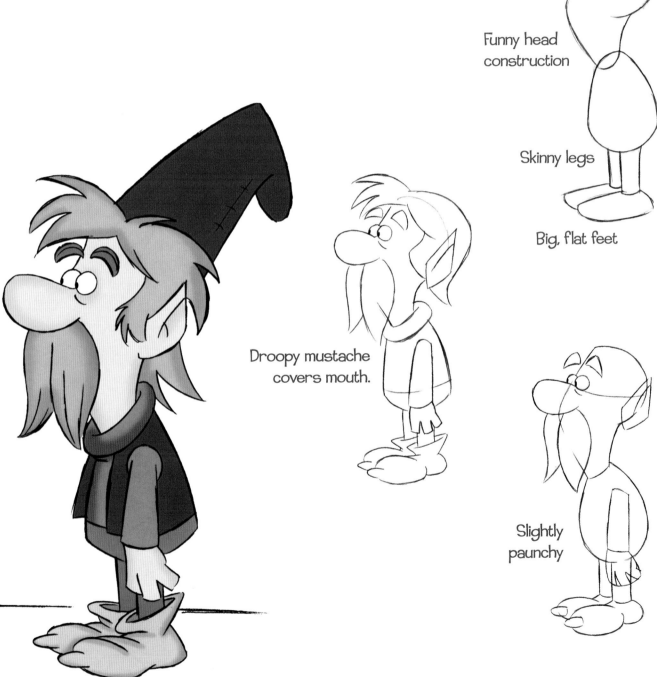

Funny head construction

Skinny legs

Big, flat feet

Droopy mustache covers mouth.

Slightly paunchy

A WITCH AND HER PAL

Witches don't text much. Instead, they rely on animals to warn them about things. A bird is a particularly useful messenger because it can fly over the treetops to bring advanced word of impending trouble.

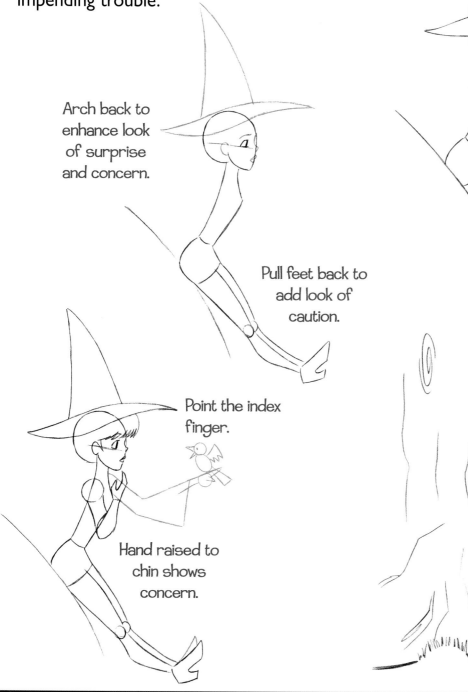

Arch back to enhance look of surprise and concern.

Pull feet back to add look of caution.

Point the index finger.

Hand raised to chin shows concern.

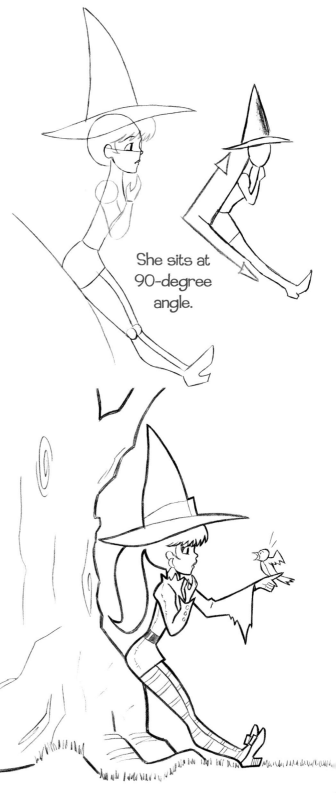

She sits at 90-degree angle.

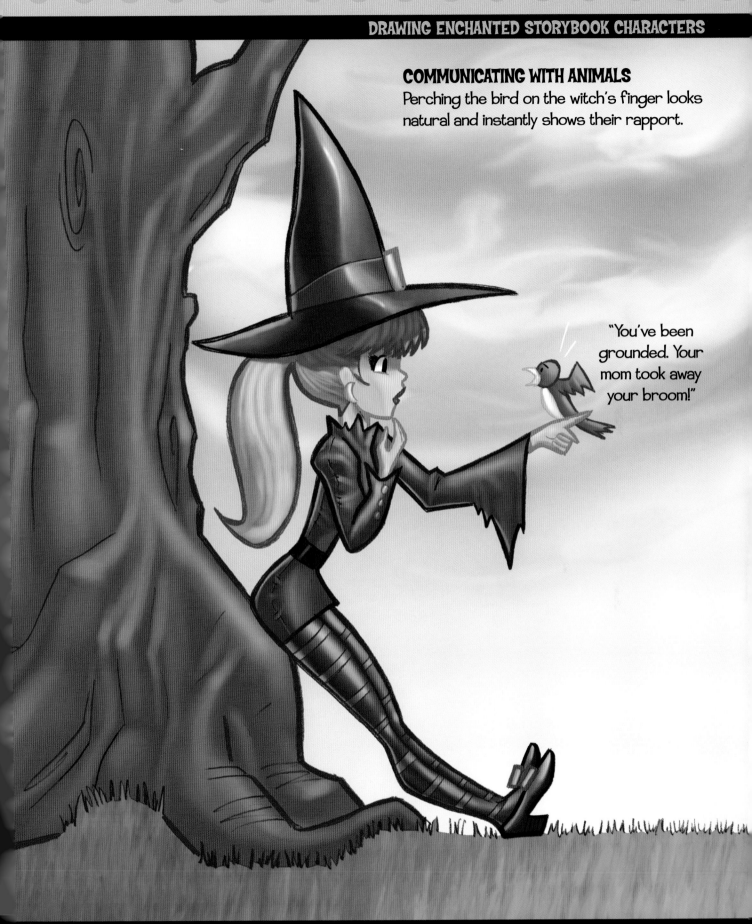

COMMUNICATING WITH ANIMALS
Perching the bird on the witch's finger looks natural and instantly shows their rapport.

"You've been grounded. Your mom took away your broom!"

PRETTY WITCH

With attractive eyes, full lips, and long, curly hair, witches can be quite beautiful. Note the dynamic pose: the trunk of the body actually twists. You can see that by following the center line as it travels down the length of the body.

The far shoulder pokes out just a bit.

Her arm is partially hidden by the body, creating a feeling of depth.

The center line shows the twist of the torso.

Draw the entire line of the broomstick first, then draw the two hands over it.

There is a pocket of shadow at her neckline.

The stitching on the dress mimics the center line of the body.

Her dress casts a shadow on her legs.

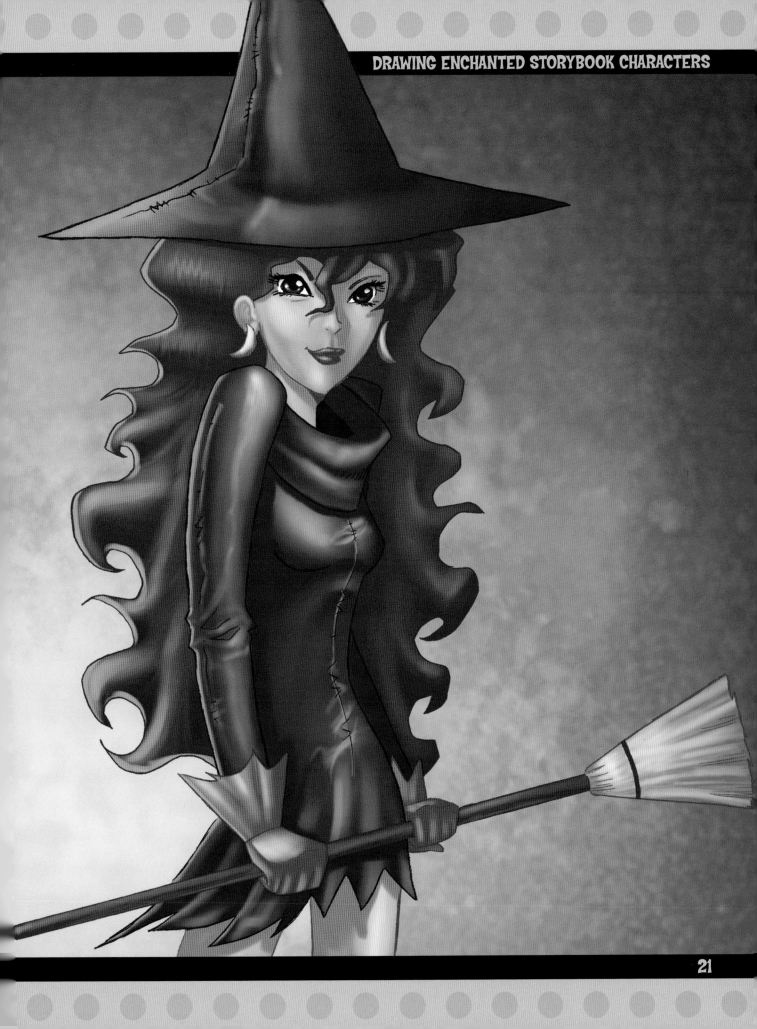

WIZARD

Wizards often emerge out of the mists of the forest, carrying a craggy branch as a staff. He is a particularly mysterious character. His robes are basic, never flamboyant, and he wears a hat with a brim.

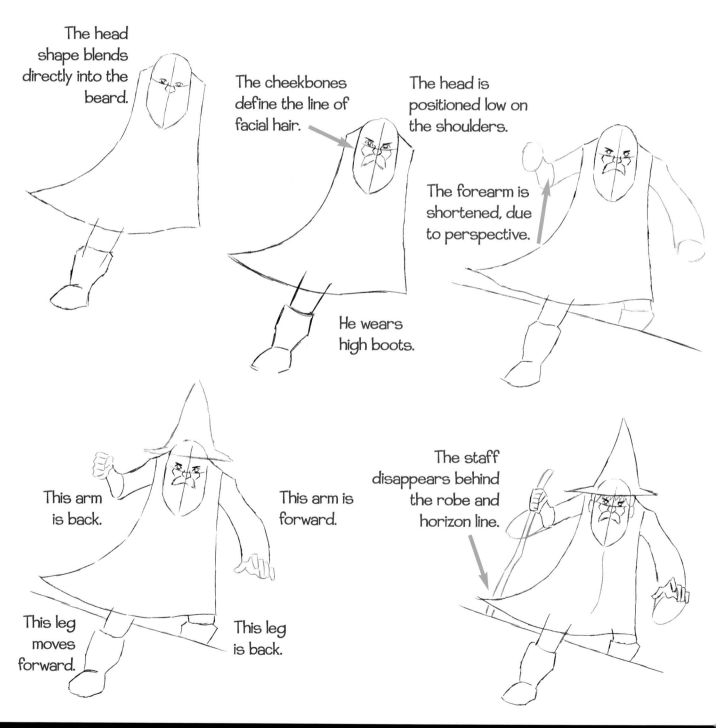

The head shape blends directly into the beard.

The cheekbones define the line of facial hair.

The head is positioned low on the shoulders.

The forearm is shortened, due to perspective.

He wears high boots.

This arm is back.

This arm is forward.

The staff disappears behind the robe and horizon line.

This leg moves forward.

This leg is back.

POSTURE AND AGE

An effective way to convey the age of older characters is to draw the head low on the shoulders, which makes the back appear to hunch forward.

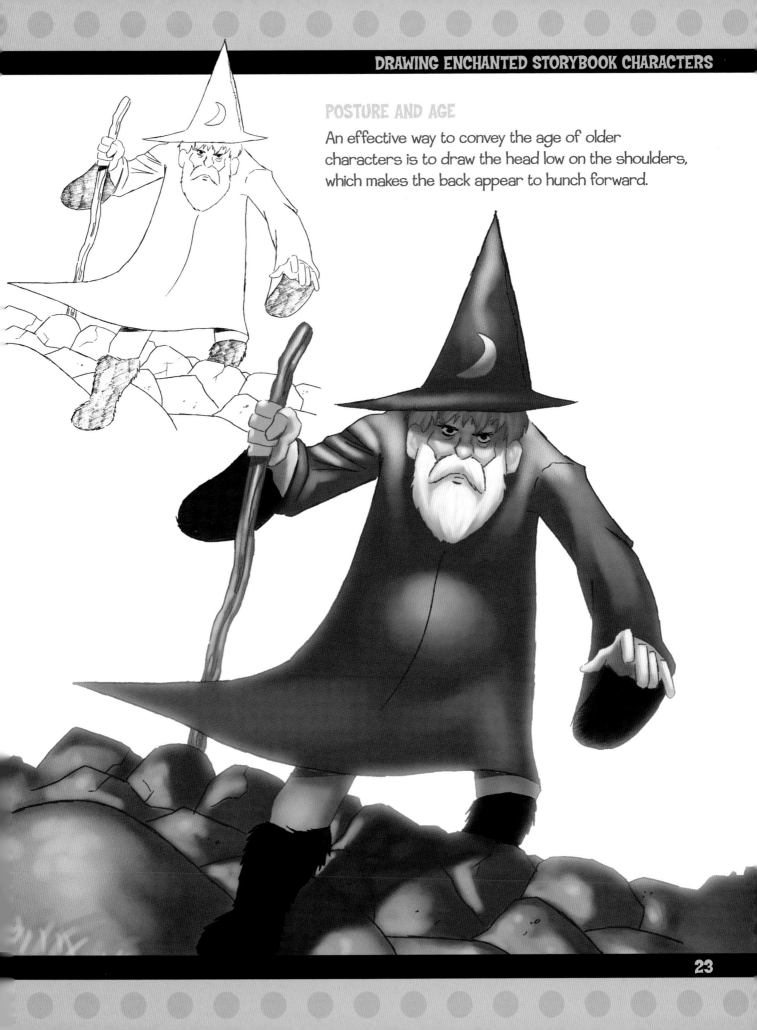

GUARDIAN ANGEL

The guardian angel figure is grandfatherly, with a caring and kind demeanor. He might sport a cane or an umbrella, a confident look, and a twinkle in his eye. Keep in mind that it helps to draw the entire body first, even if it will later be obscured by clothing.

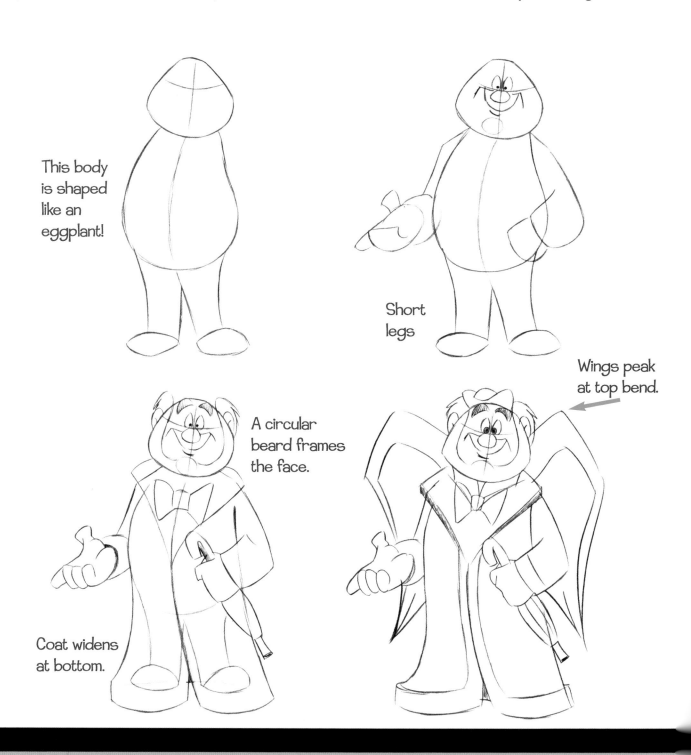

This body is shaped like an eggplant!

Short legs

A circular beard frames the face.

Coat widens at bottom.

Wings peak at top bend.

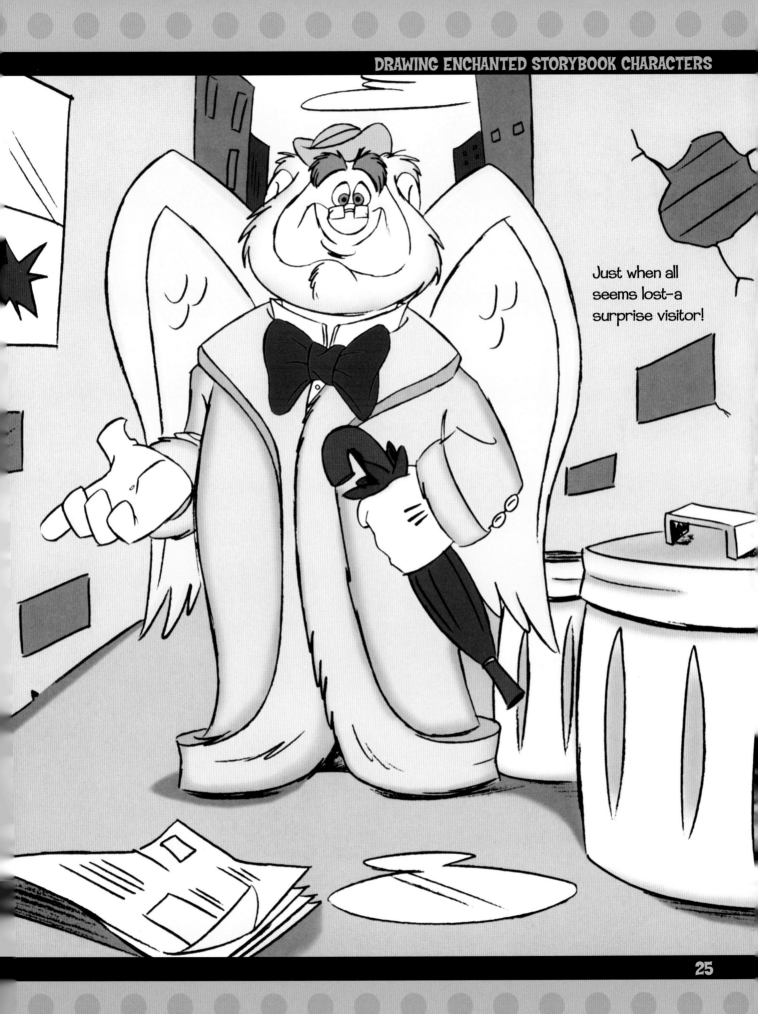

Just when all seems lost-a surprise visitor!

FAIRY GODMOTHER

Another popular character in animated films and picture books, a fairy godmother can also appear when the hero is desperate and has nowhere else to turn. Fairy godmothers and godfathers are often drawn as humorous characters.

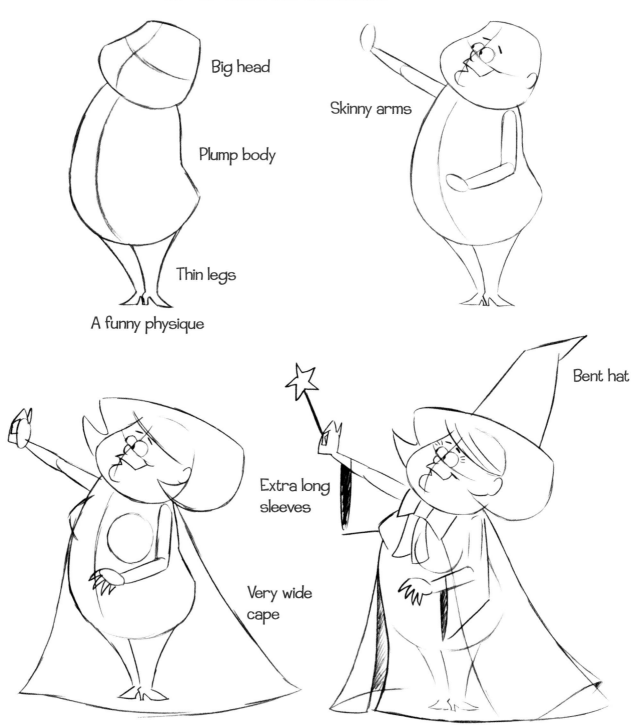

Big head

Plump body

Skinny arms

Thin legs

A funny physique

Extra long sleeves

Very wide cape

Bent hat

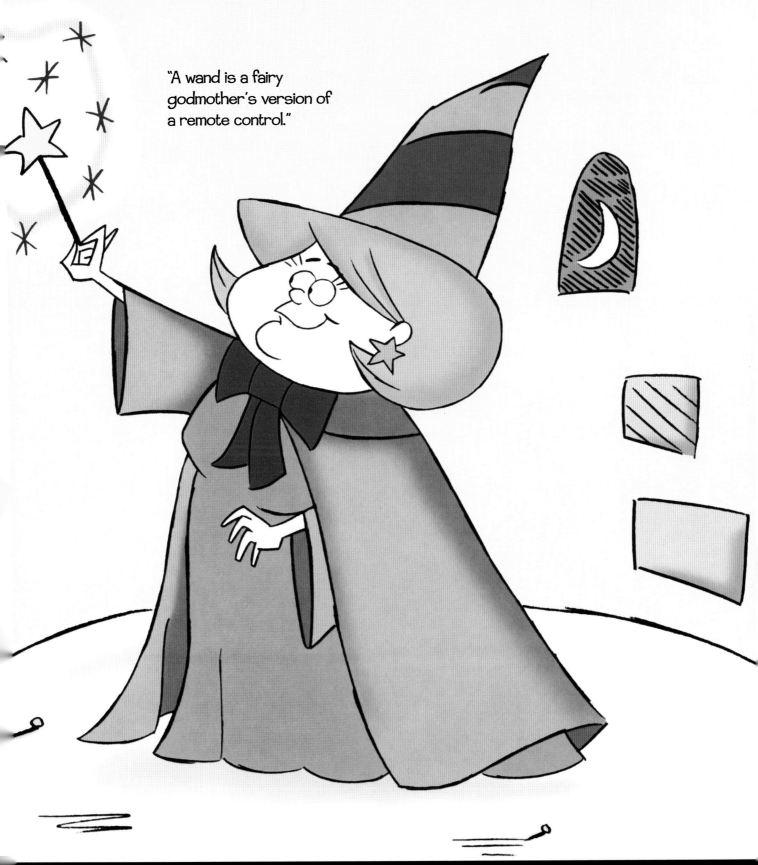

"A wand is a fairy godmother's version of a remote control."

EVIL KING

The evil king is large and impressive. He has heavy eyebrows, which are great for making a menacing expression. His hair is unkempt, giving him a wild, unpredictable look. His low forehead makes him seem thuggish.

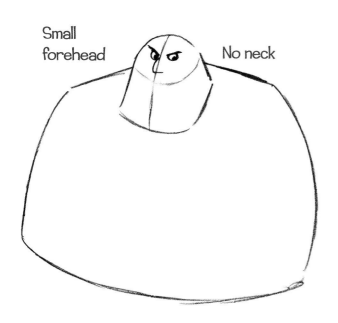

Small forehead

No neck

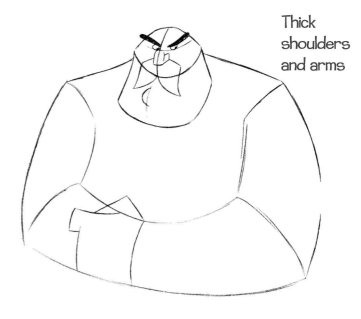

Thick shoulders and arms

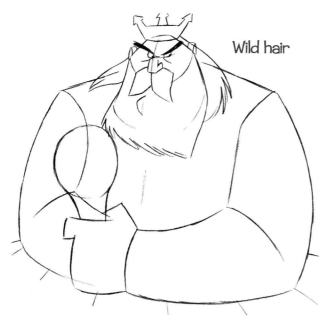

Wild hair

Big hands, too!

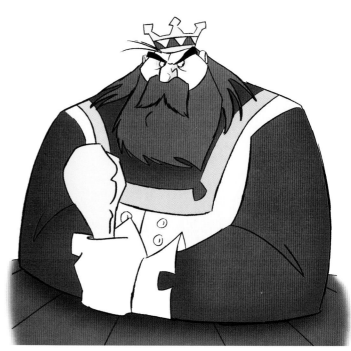

He only wants to hear good news.

KIND (BUT STUPID) KING

One common representation of a monarch is that of the kind but stupid king, who is easily manipulated by his wicked advisors. Focus on the sleepy eyes with heavy eyelids.

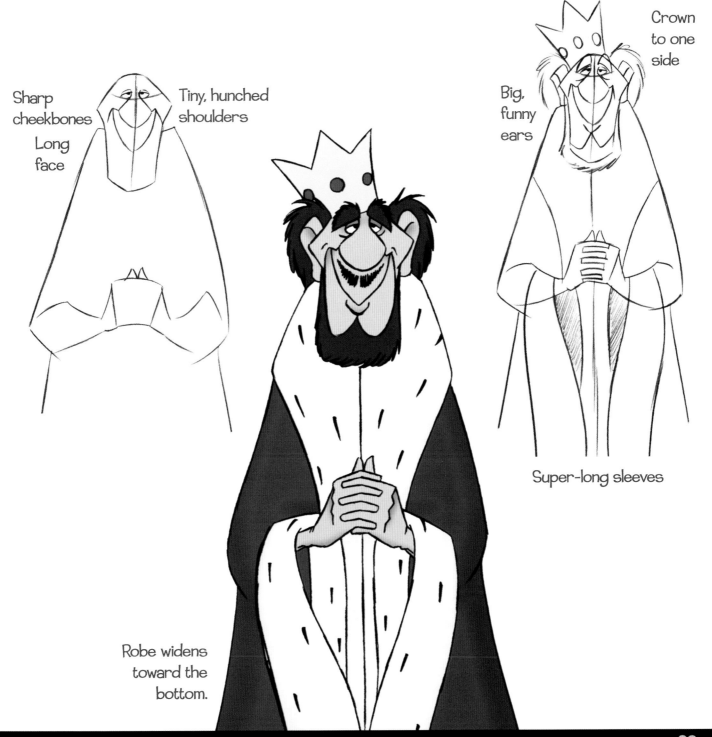

Sharp cheekbones

Long face

Tiny, hunched shoulders

Crown to one side

Big, funny ears

Super-long sleeves

Robe widens toward the bottom.

THE DRAGON

KING OF THE BEASTS

Legendary and gothic, the dragon is the most powerful beast in the fantasy realm. It possesses a complete arsenal of weapons and special abilities: sheer size and strength, flight, sharp horns and claws, a whip-like tail, razor-sharp teeth, and of course, fire.

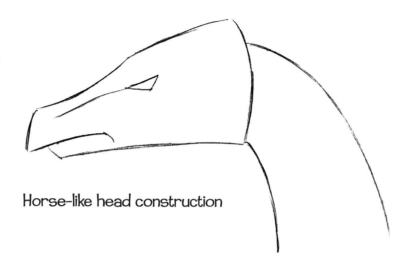

Horse-like head construction

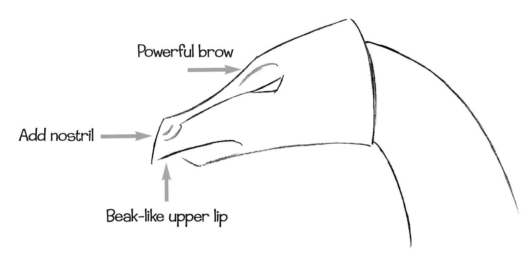

Powerful brow

Add nostril

Beak-like upper lip

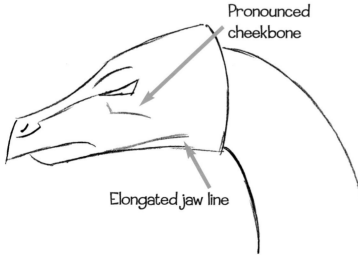

Pronounced cheekbone

Elongated jaw line

BASIC DRAGON HEAD

The basic outline of the dragon's head is vaguely reminiscent of a horse's head. But as the steps progress, the outline becomes more angular and severe, until the final result does not resemble a horse in any way.

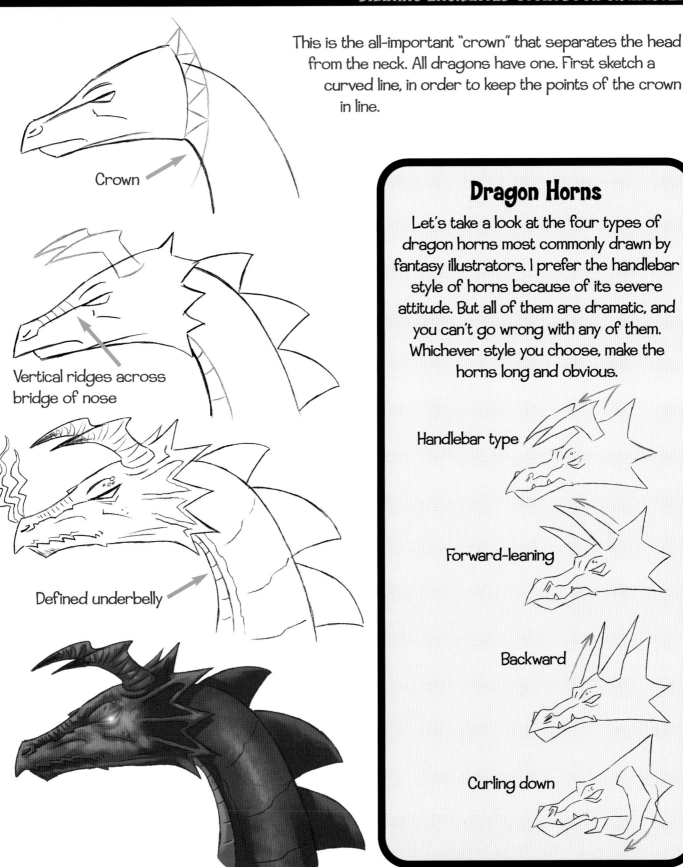

This is the all-important "crown" that separates the head from the neck. All dragons have one. First sketch a curved line, in order to keep the points of the crown in line.

Crown

Vertical ridges across bridge of nose

Defined underbelly

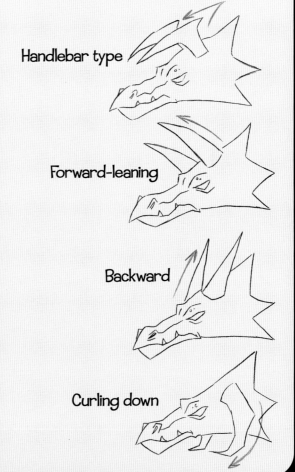

Dragon Horns

Let's take a look at the four types of dragon horns most commonly drawn by fantasy illustrators. I prefer the handlebar style of horns because of its severe attitude. But all of them are dramatic, and you can't go wrong with any of them. Whichever style you choose, make the horns long and obvious.

Handlebar type

Forward-leaning

Backward

Curling down

CARTOON DRAGON

Dragons can be drawn in many different ways, with or without wings, and with various types of horns. They can be evil, sly, or even funny. They can be green, blue, red, grey, or yellow. But, they always have dorsal plates and long tails, and they are always derived from reptiles.

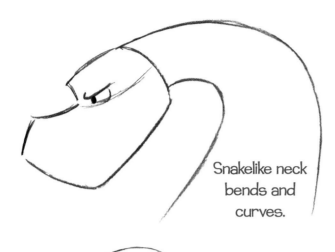

Snakelike neck bends and curves.

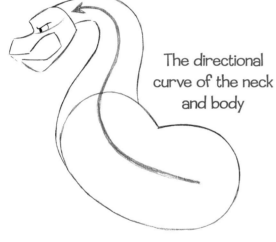

The directional curve of the neck and body

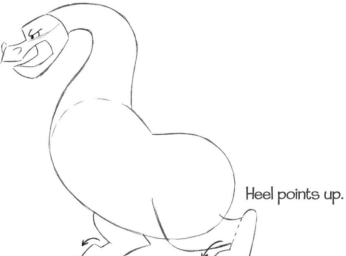

Heel points up.

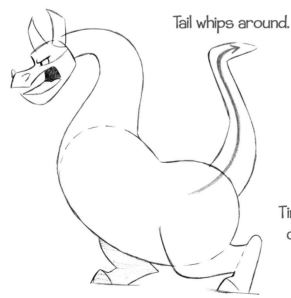

Tail whips around.

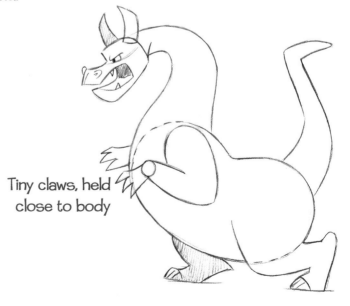

Tiny claws, held close to body